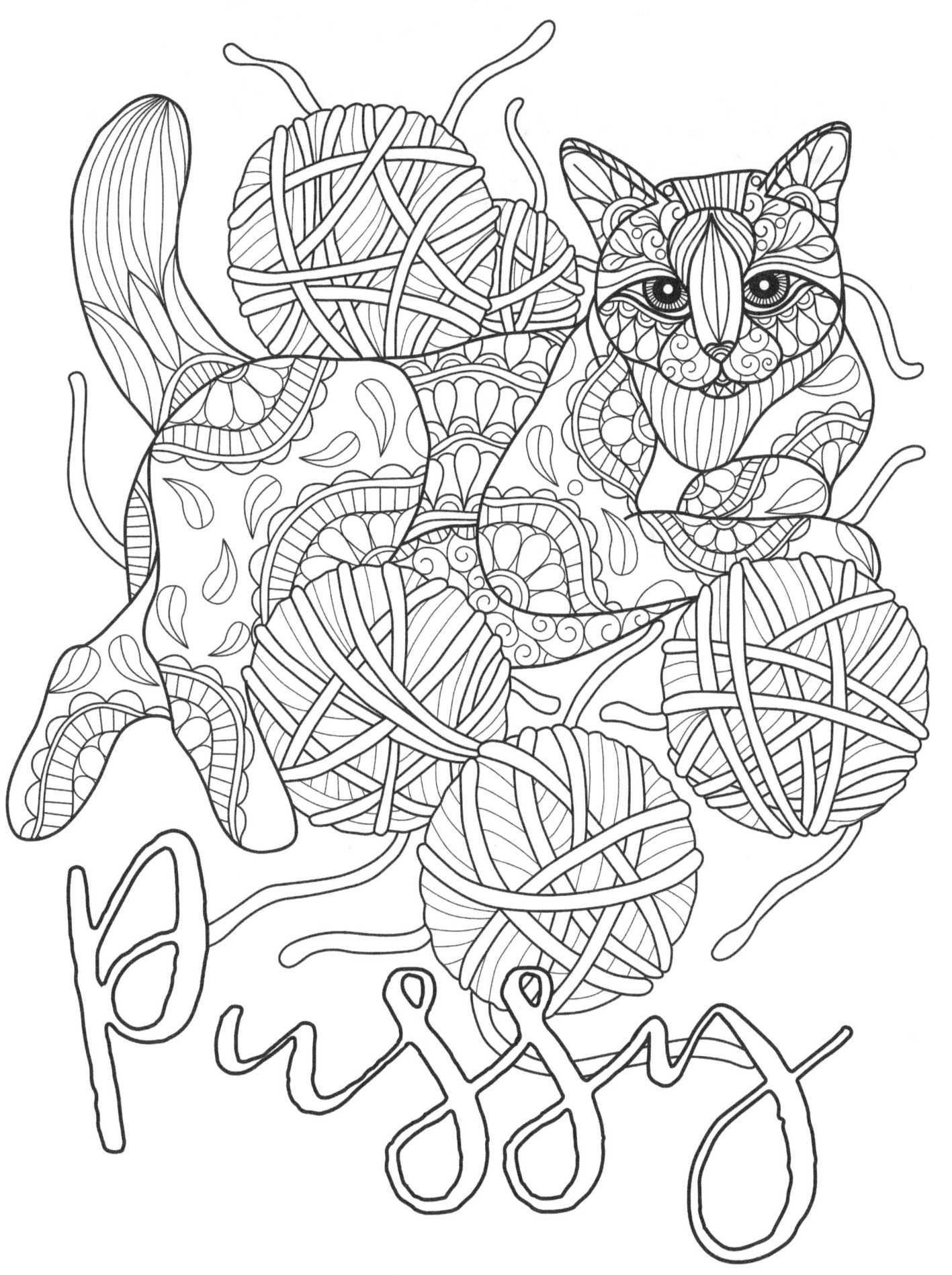

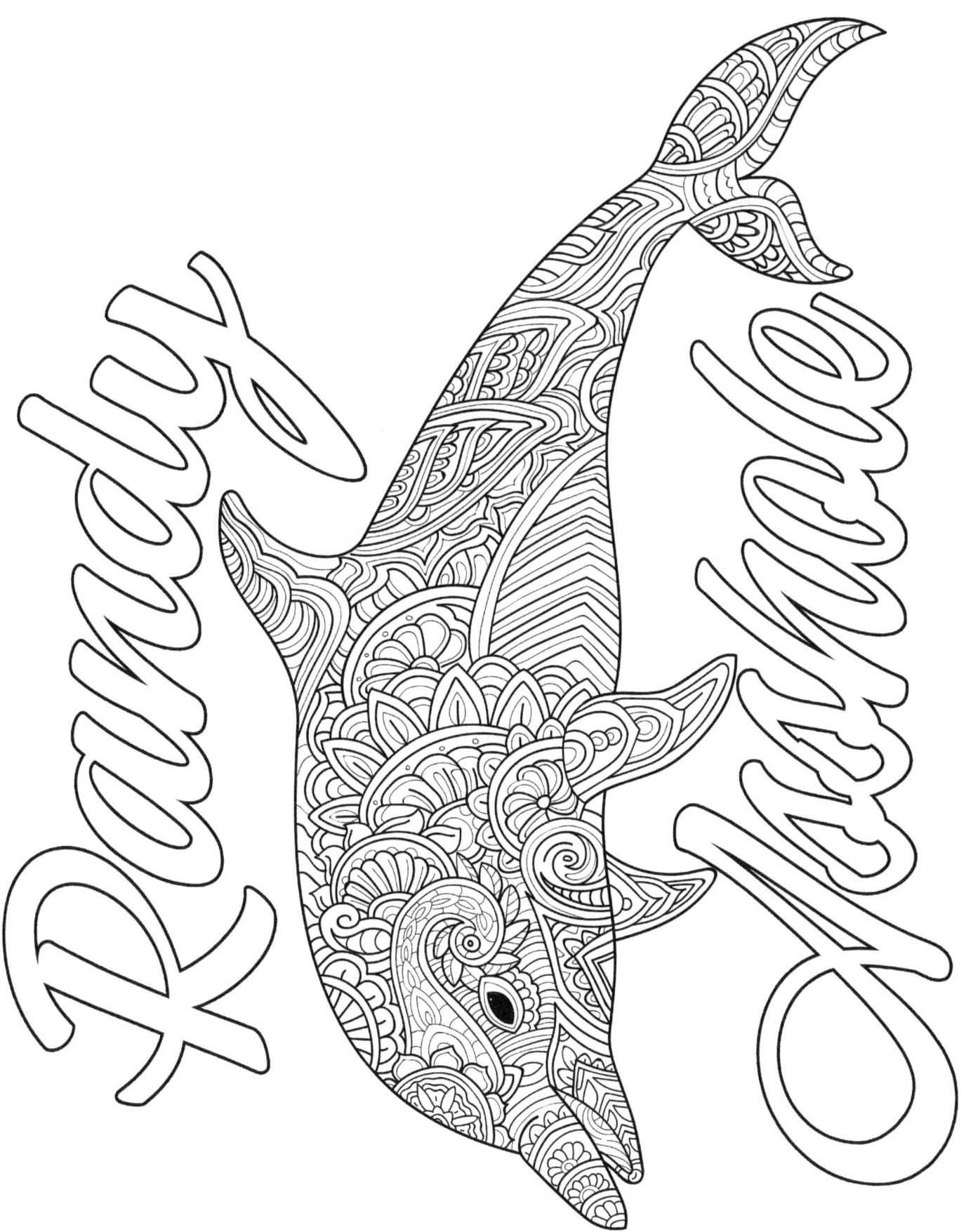

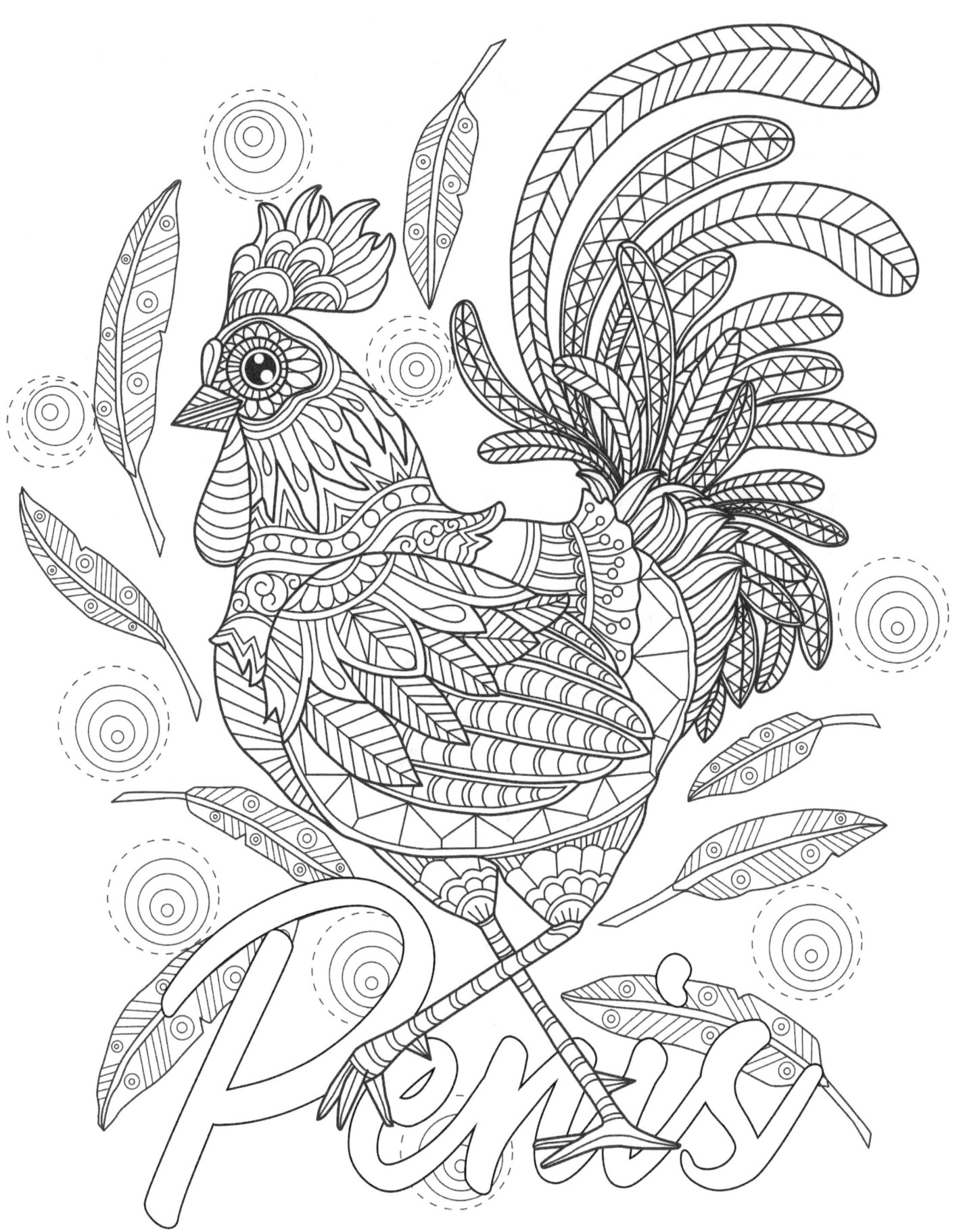

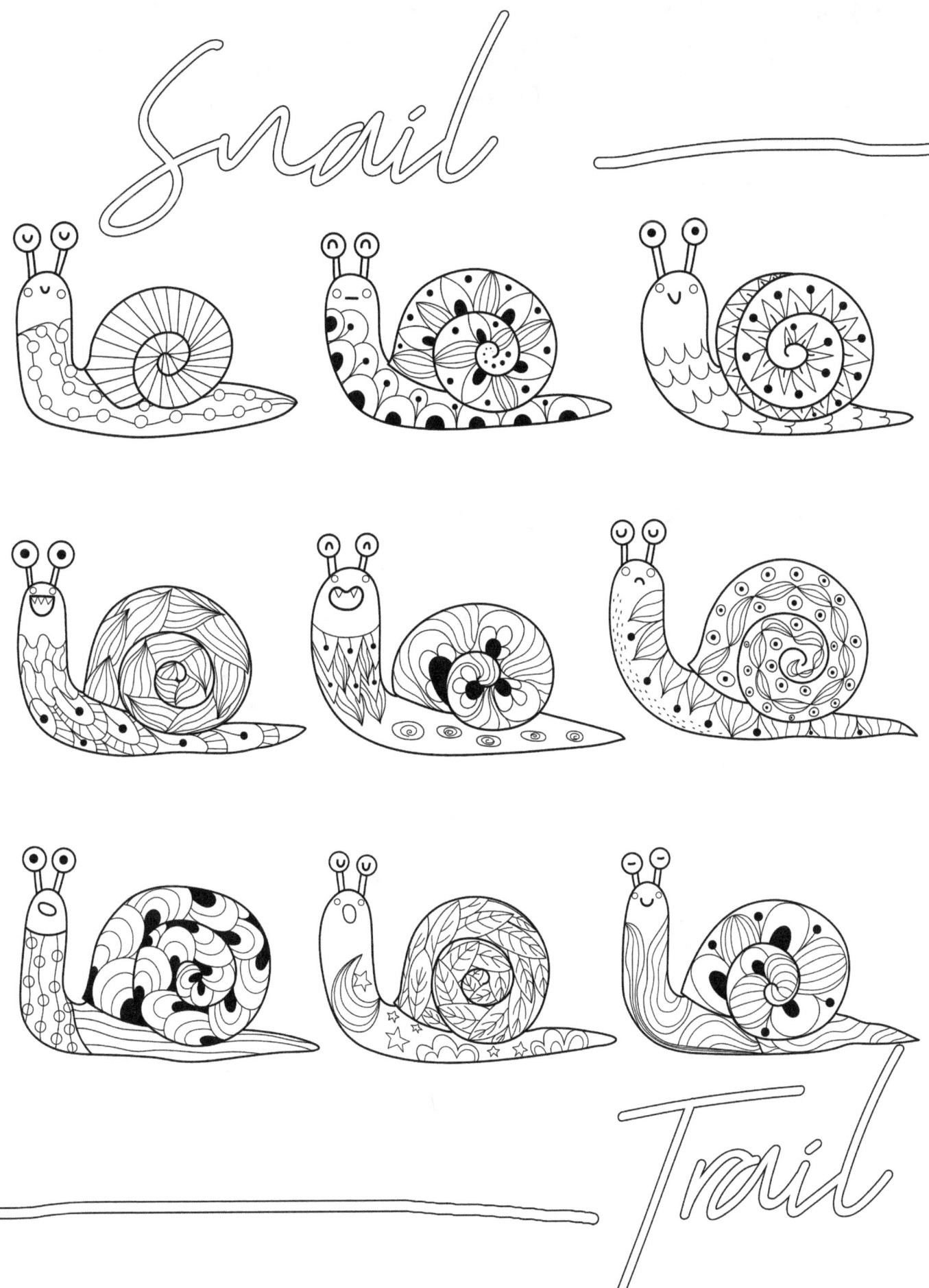

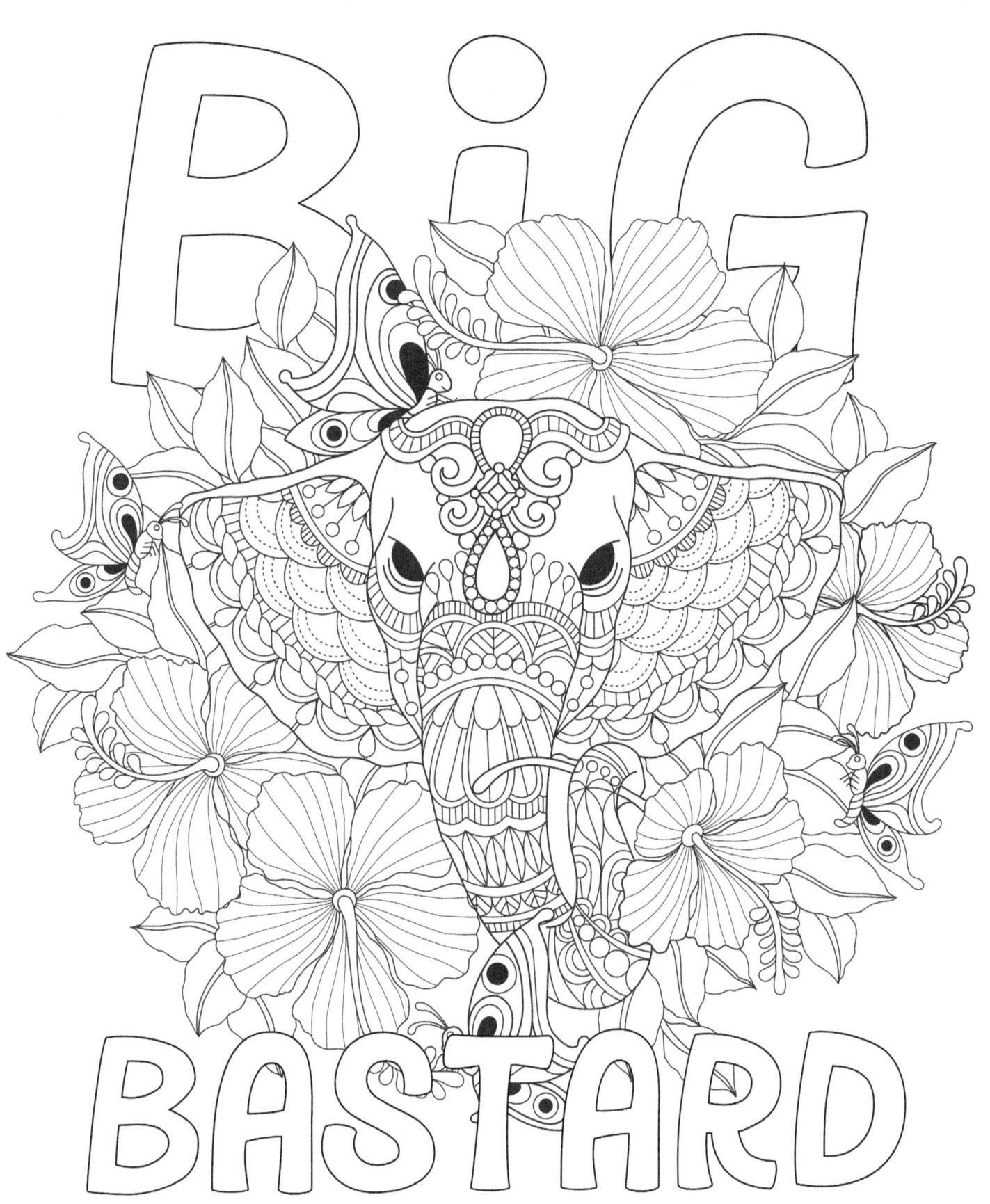

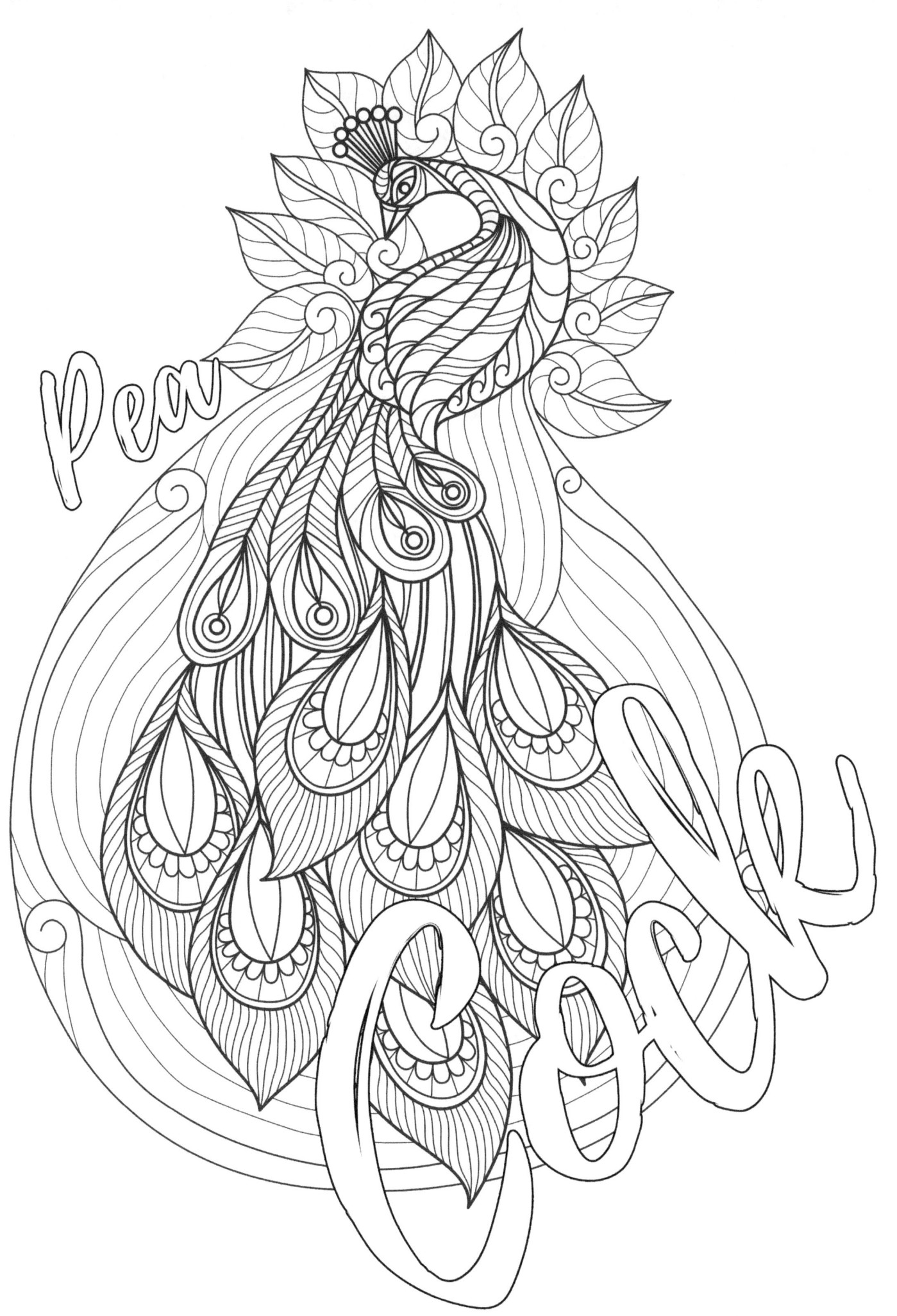

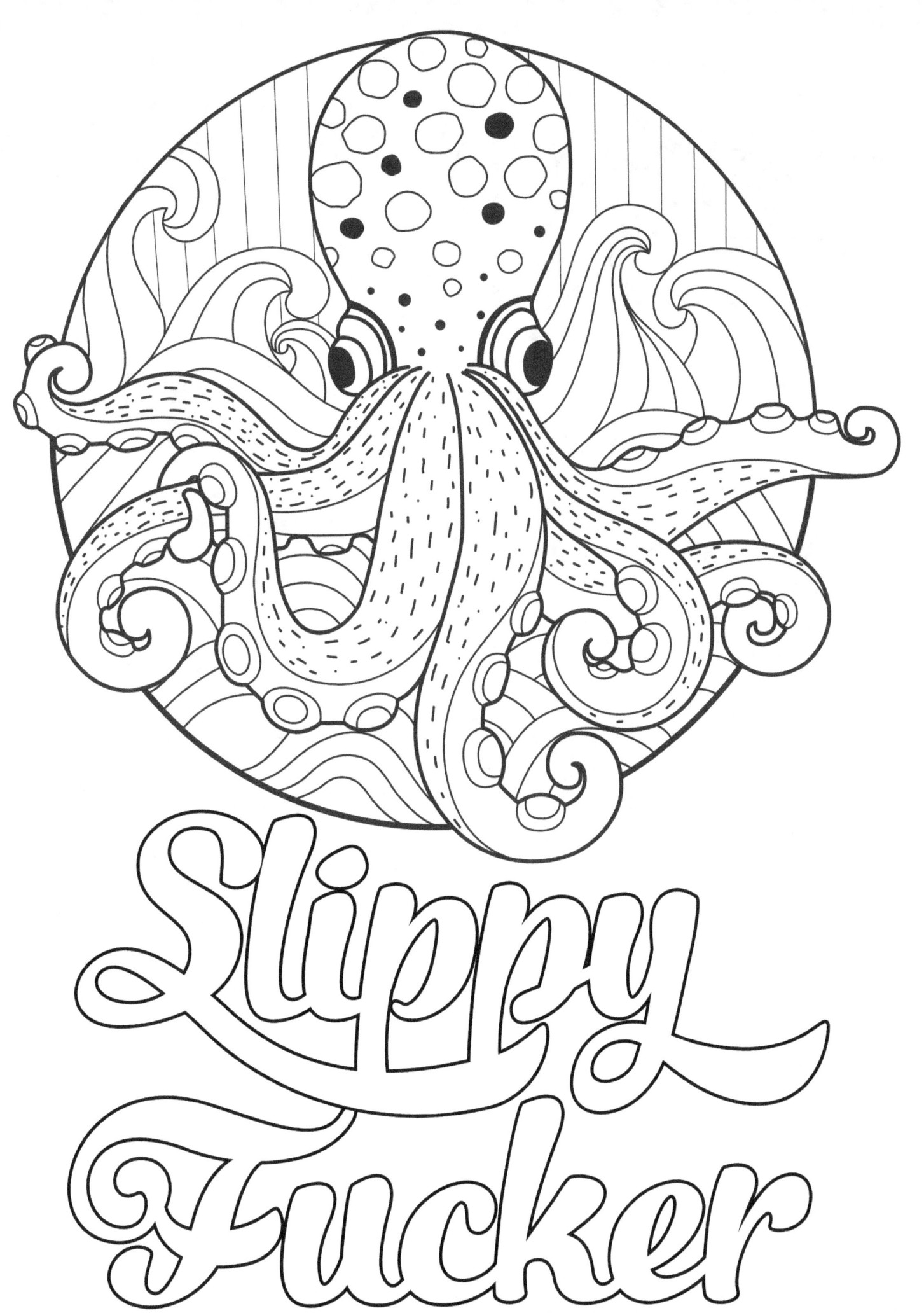

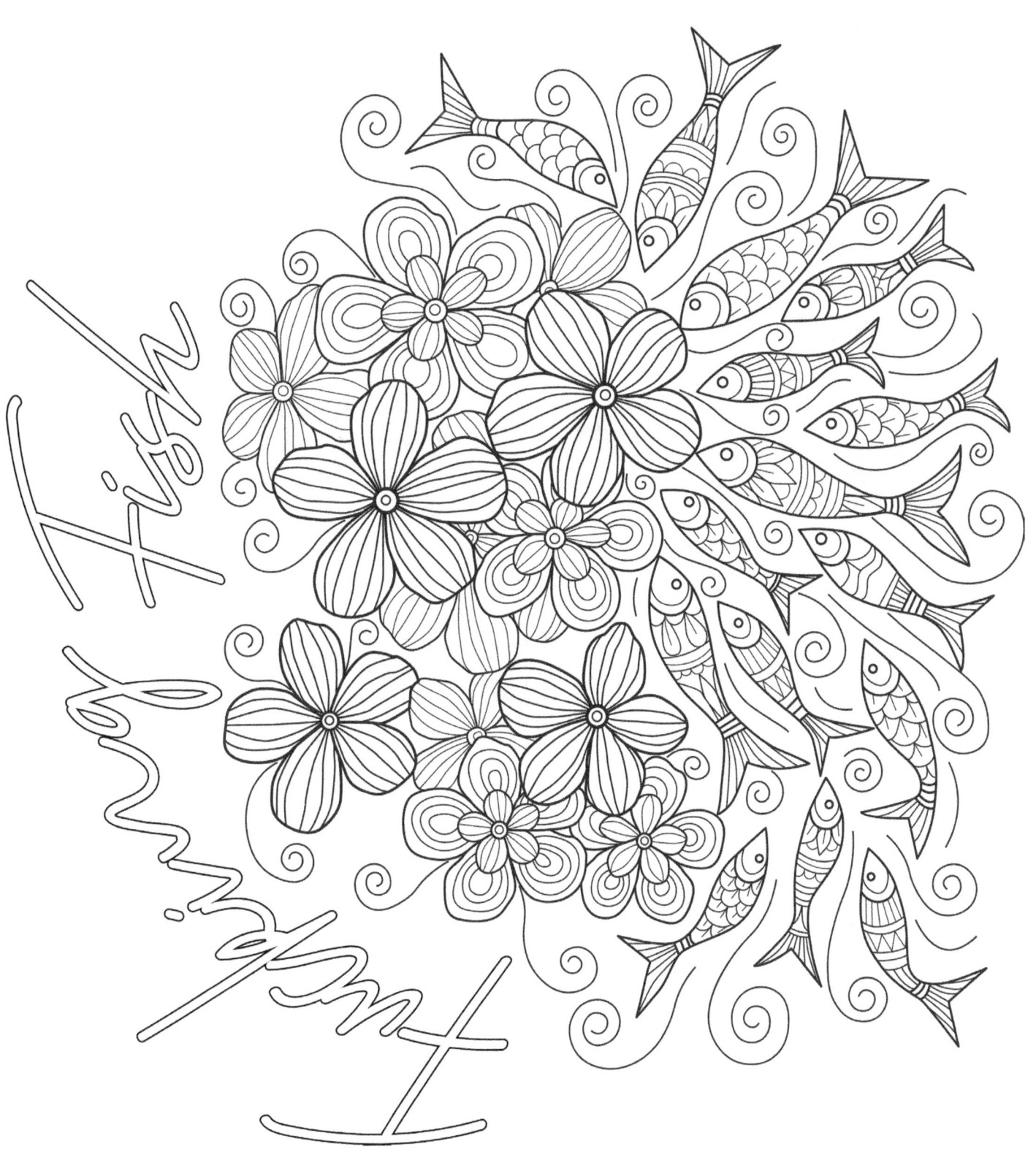

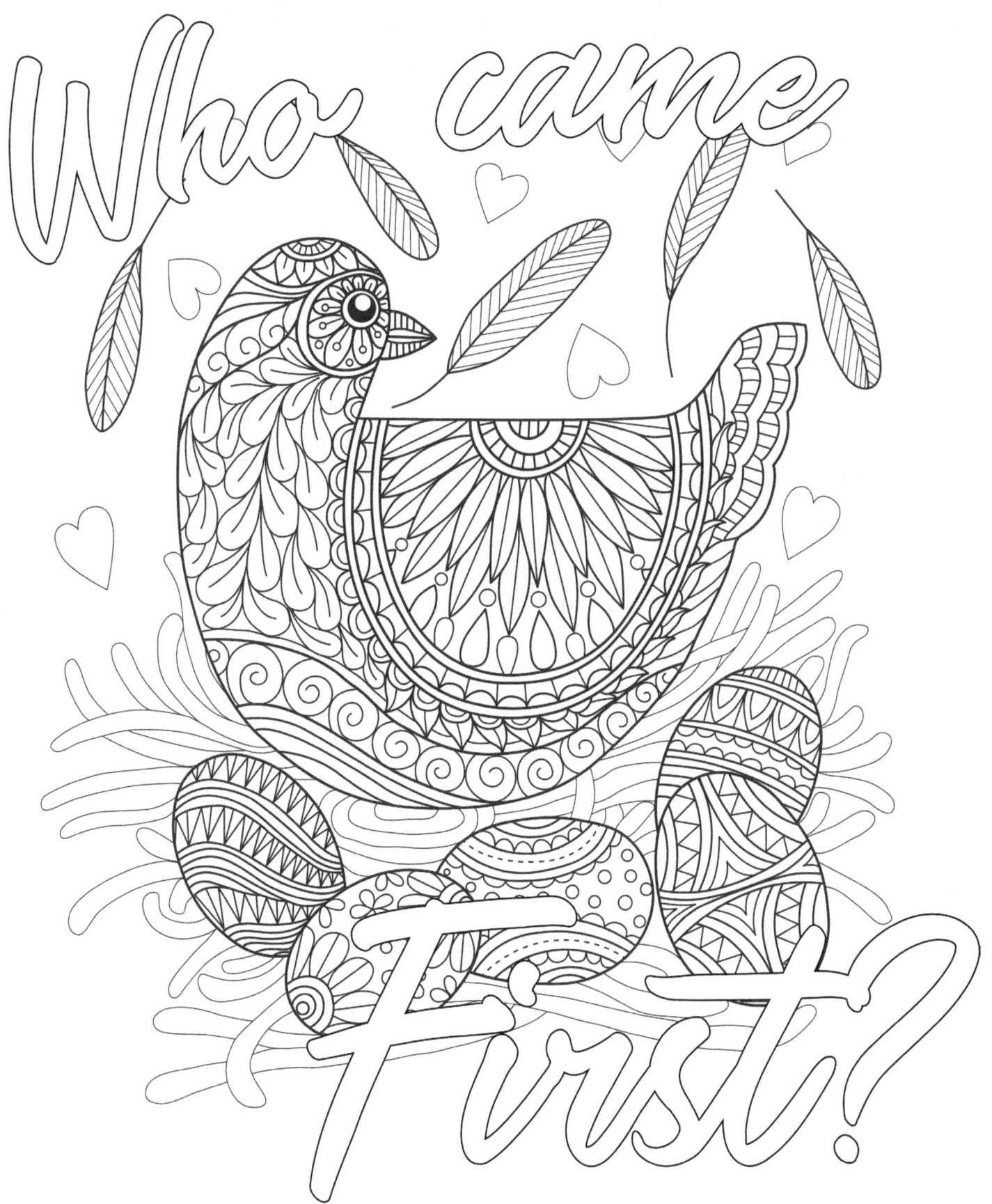

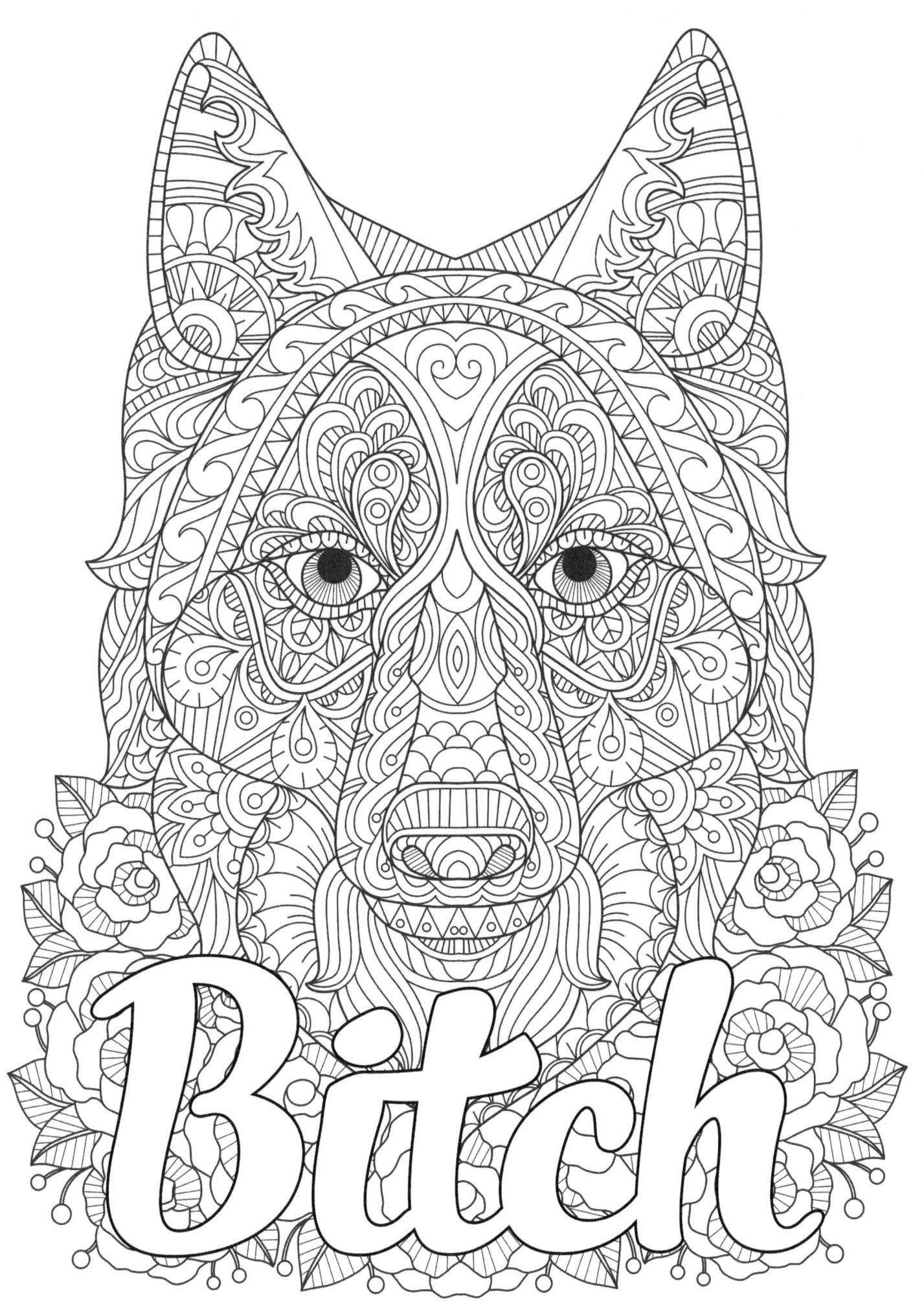

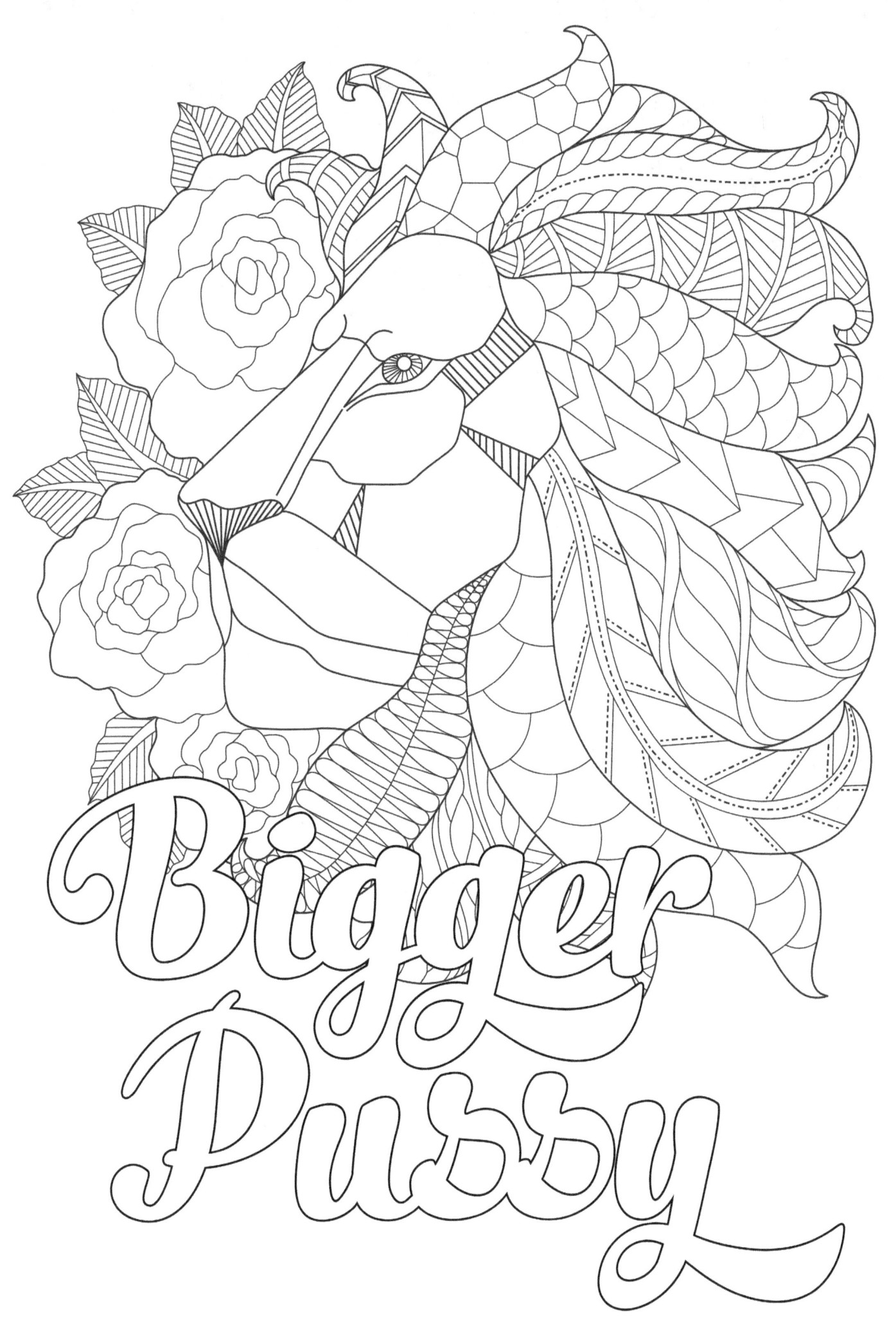

Open up Your Butterfly

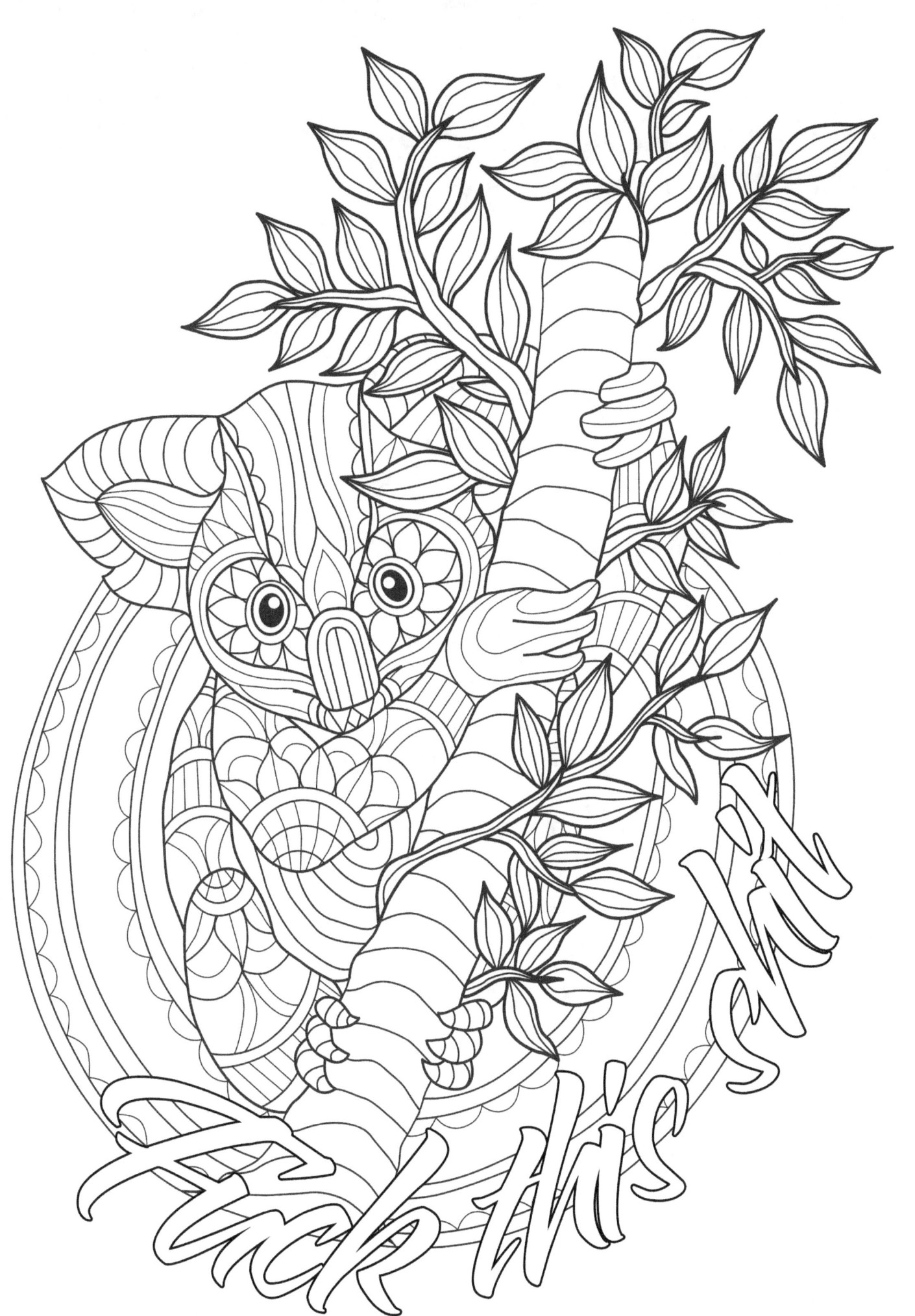

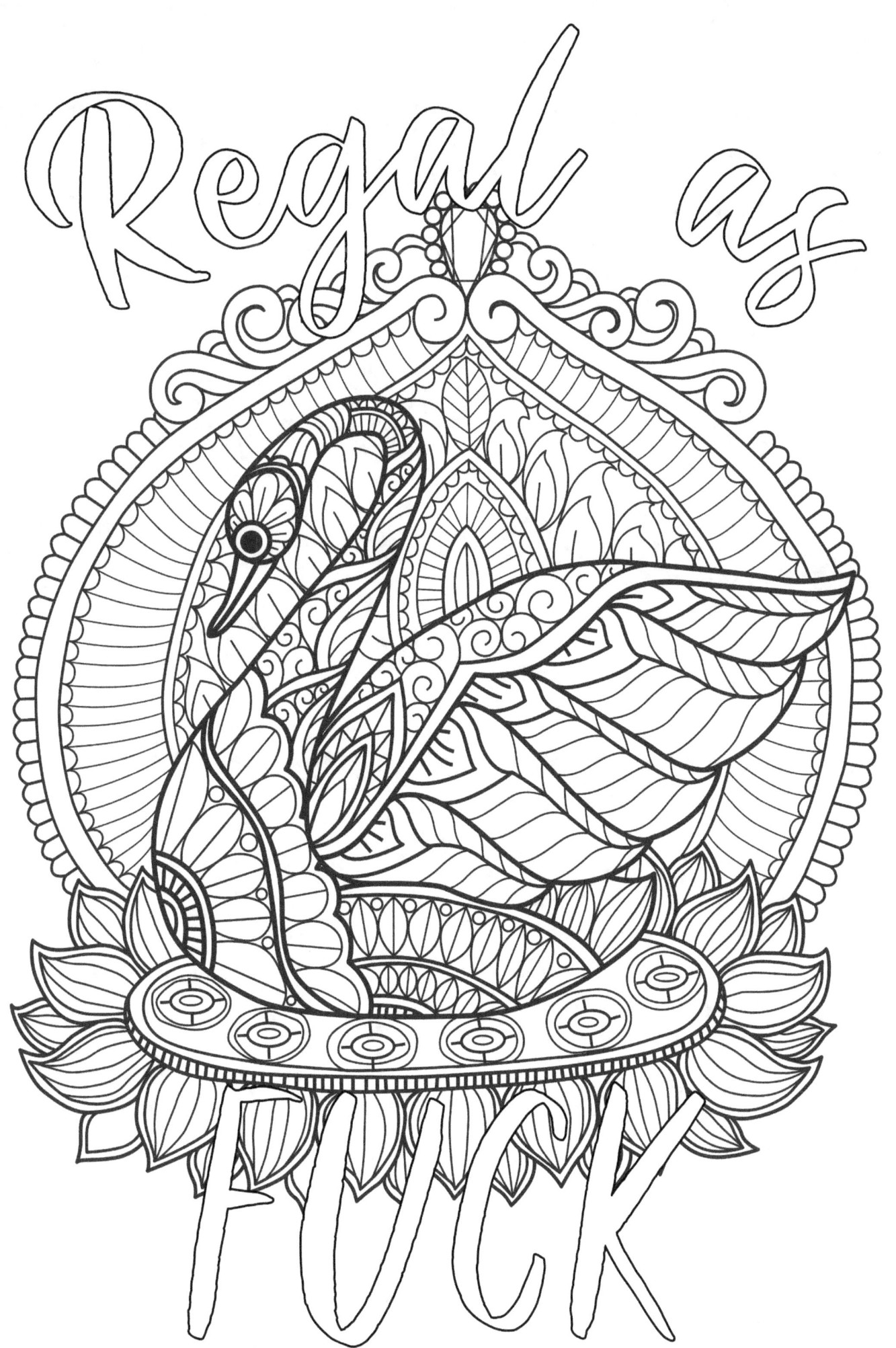

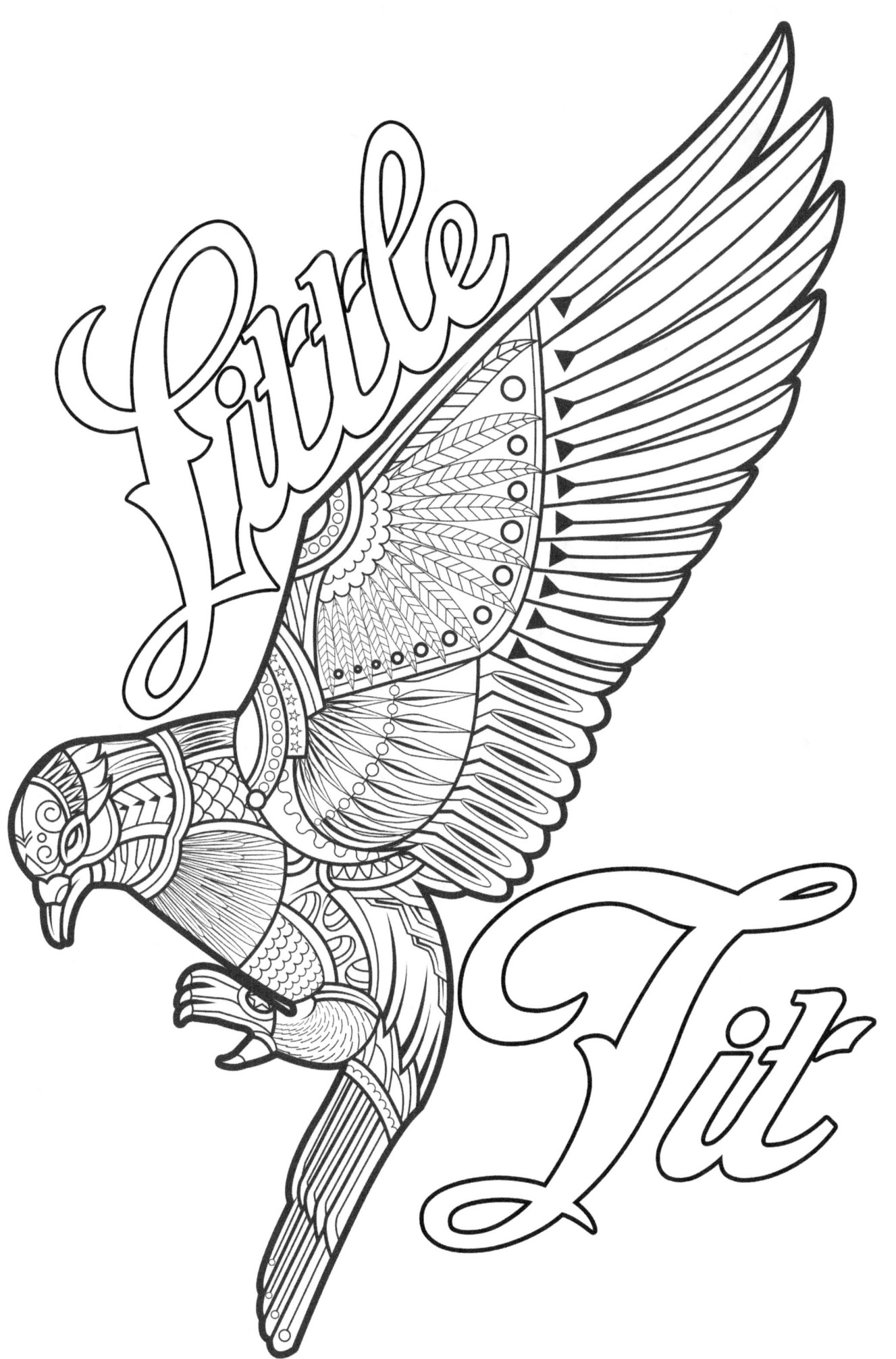

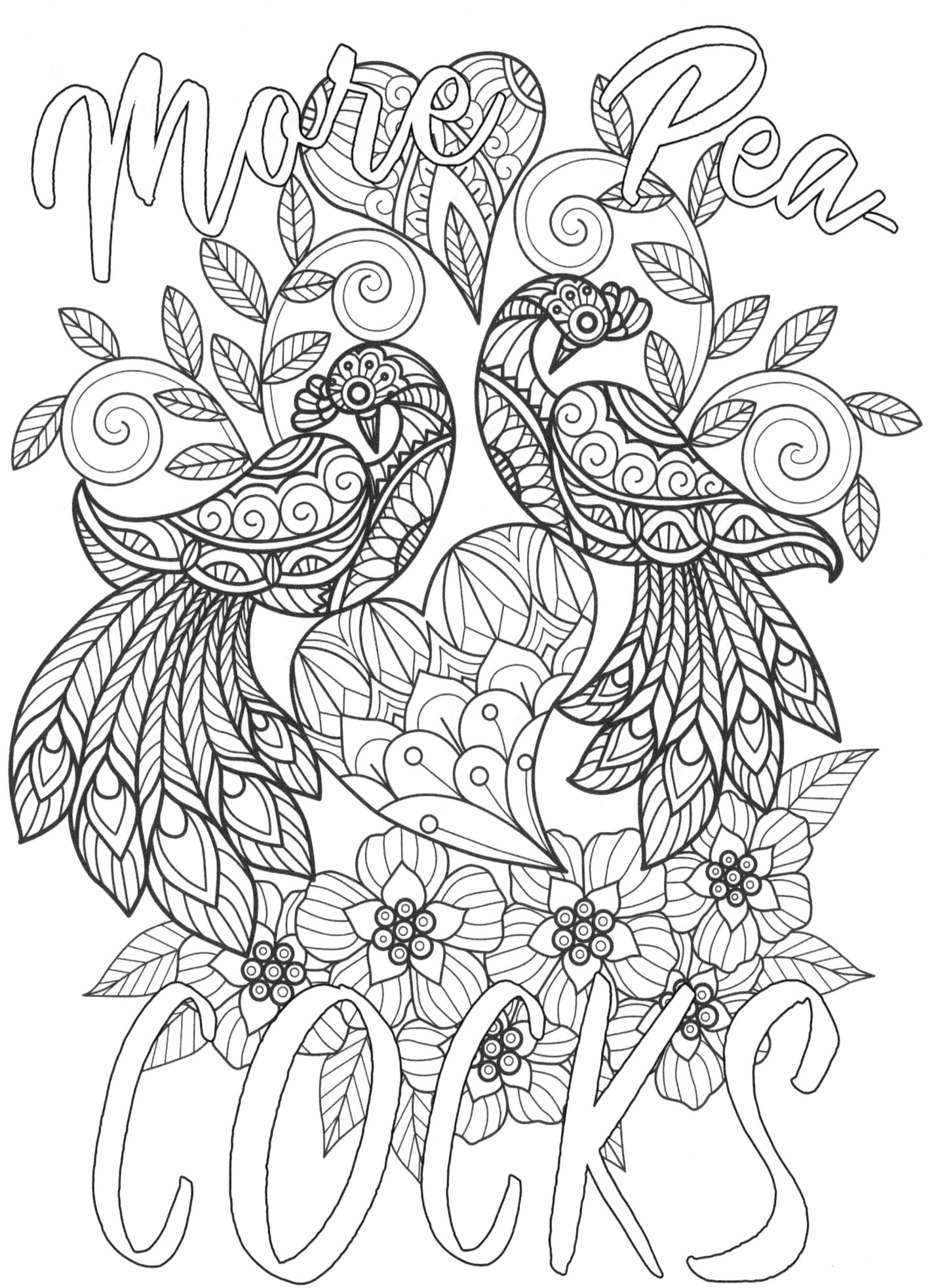

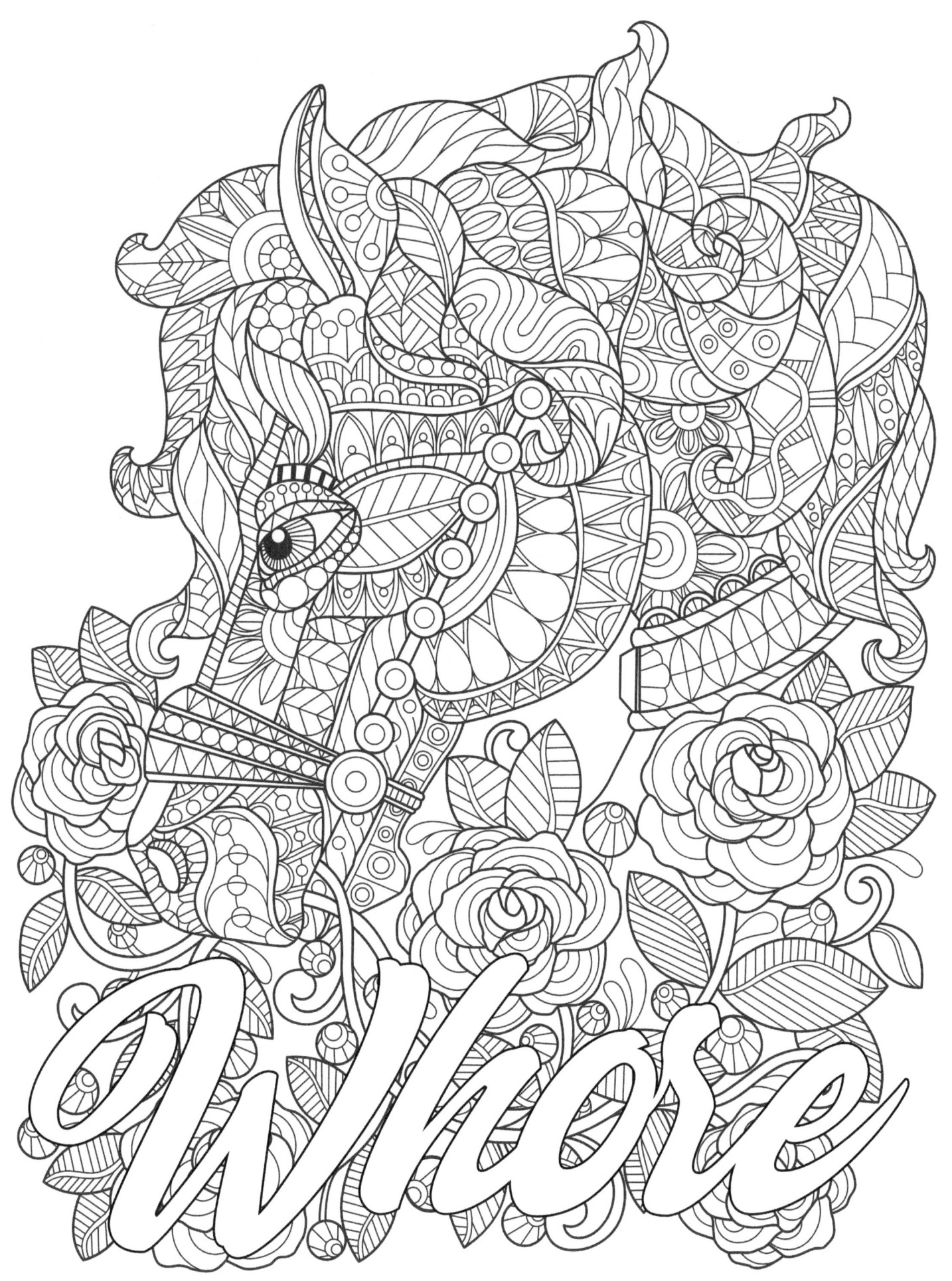

www.ingramcontent.com/pod-product-compliance
Lightning Source LLC
Chambersburg PA
CBHW081705220526
45466CB00009B/2890